COMFORT
RECLAIMING PLACE IN A VIRTUAL WORLD

Cleveland Center for Contemporary Art

COMFORT
RECLAIMING PLACE IN A VIRTUAL WORLD

FRANZ ACKERMANN PETER LAND SARAH MORRIS GABRIEL OROZCO
JORGE PARDO TOBIAS REHBERGER GREGOR SCHNEIDER ANDREA ZITTEL

CONTRIBUTIONS BY
KRISTIN CHAMBERS MICHAEL SORKIN

COMFORT: RECLAIMING PLACE IN A VIRTUAL WORLD
HAS BEEN PUBLISHED ON THE OCCASION OF THE EXHIBITION AT THE
CLEVELAND CENTER FOR CONTEMPORARY ART
MARCH 9–MAY 20, 2001.

COMFORT: RECLAIMING PLACE IN A VIRTUAL WORLD and
the accompanying catalogue have been supported by
a grant from the National Endowment for the Arts,
a federal agency, and an anonymous donor. The corpo-
rate sponsor is Metropolitan Bank & Trust. Additional
support has been provided by The Elizabeth Firestone
Graham Foundation, A. T. Kearney, and the American
Scandinavian Foundation.

CLEVELAND CENTER FOR CONTEMPORARY ART
8501 CARNEGIE AVENUE
CLEVELAND, OHIO 44106
www.contemporaryart.org

Library of Congress Catalogue Card Number 00-110055
ISBN 1-880353-18-0

CURATOR
KRISTIN CHAMBERS

EDITOR
LARRY GILMAN

DESIGNERS
LAURIE HAYCOCK MAKELA, DAVID CABIANCA

PRINTER AND BINDERY
DR. CANTZ'SCHE DRUCKEREI, GERMANY

AVAILABLE THROUGH
D.A.P./DISTRIBUTED ART PUBLISHERS
155 SIXTH AVENUE, 2ND FLOOR
NEW YORK, NEW YORK 10013
TEL 212 627-1999
FAX 212 627-9484

FRONT AND BACK COVER Peter Land

Detail from **THE STAIRCASE**, 1998

Double video projection

Photos courtesy of Galleri Nicolai Wallner, Copenhagen

COMFORT
RECLAIMING PLACE IN A VIRTUAL WORLD

THE CLEVELAND CENTER FOR CONTEMPORARY ART is proud to present **COMFORT: RECLAIMING PLACE IN A VIRTUAL WORLD**. Unquestionably, new technologies and the virtual world have redefined our playing field. As human interaction becomes characterized by an increasingly complex array of exchanges, alterations to our emotional and psychological bearings have begun to surface. **COMFORT: RECLAIMING PLACE IN A VIRTUAL WORLD** tackles this topical global phenomenon through the examination of eight international contemporary artists. In truly postmodern fashion, the aesthetics and conceptual precepts of the works assembled here reference radical historic movements of utopianism, existentialism, isolationism, and Marxism. Yet, these artists eschew dogma in favor of quirky, individualist visions that voice desire, memory, and wonderment. Indeed, the irrepressible and intense human aspiration to feel is very present, even effervescent in this energetic exhibition.

I would like to express our deep and abiding appreciation to an anonymous friend of the Center who continues to play a central role in supporting new, ambitious curatorial projects. We are most grateful to the National Endowment for the Arts for their support of this project, and to Metropolitan Bank & Trust for assuming major corporate sponsorship for this exhibition and its accompanying publication. Additional support has been generously provided by The Elizabeth Firestone Graham Foundation, A.T. Kearney, and the American Scandinavian Foundation. The Center's Board of Trustees and patrons provide ongoing support for our curatorial program. Their leadership, devotion, and commitment deserve special acknowledgement and praise.

FOREWORD

JILL SNYDER, EXECUTIVE DIRECTOR

The Center's team is singularly responsible for the success of this exhibition. Each individual has contributed in their area of expertise and devoted much time and effort in the realization of this project. I am very grateful for the abundant talent and collective wisdom of our team. Kristin Chambers, Curator for this exhibition, has devoted not only time and energy, but heart and soul to this project. Her vision of a truly global exhibition in theme and artist selection has yielded an exciting, fresh, and immeasurably interesting product. It is always the hope that an exhibition will contribute to the discourse within contemporary art. This exhibition not only carries its weight intellectually, but provides endlessly pleasurable encounters with extraordinary works of art.

"I AM NEVER QUITE COMFORTABLE.
I HAVE A LOT OF ANXIETY
AND I FEEL UN**COMFORTABLE**

ABOUT BEING IN A SHOW CALLED

COMFORT."

COMFORT: RECLAIMING PLACE IN A VIRTUAL WORLD would not have been possible without the incredible support, encouragement, and enthusiasm of the entire staff and board at the Cleveland Center for Contemporary Art. My sincere thanks go to everyone who supported the idea and lent their particular skills to the realization of the project. I am enormously grateful to Jill Snyder, Executive Director, for believing in the project and for her continued support and guidance. My dear friends and colleagues at the Center—Noelle Celeste, Elizabeth McNeece, and Ginger Spivey—have been ardent supporters, passionate cheerleaders, and patient sounding boards. I thank them for championing the project every step of the way and for their enduring good humor. The exhibition is the result of a rewarding collaboration among all members of the Curatorial Department. My special thanks and continuing respect to Registrar, Ann Albano; Exhibitions Manager, Ray Juaire; and Curatorial Fellow, Amy Gilman for their diligent and skillful attention to all aspects of the exhibition.

I would like to thank the countless individuals who have assisted with the myriad of details leading up to the exhibition, from providing images to facilitating loans: Luis Campaña and Annette Völker at Galerie Luis Campaña; Marian Goodman, Linda Pellegrini, Catherine Belloy, and Elaine Budin at Marian Goodman Gallery; Tim Neuger and Jochen Volz at neugerriemschneider; Friedrich Petzel and Maureen Sarro at Friedrich Petzel Gallery; Andrea Rosen and John Conley at Andrea Rosen Gallery; Nicolai Wallner and Jacob Fabricius at Galleri Nicolai Wallner; and Alexandra Bradley at White Cube. It has been a pleasure to work with all of them and I hope to have the opportunity again. I would additionally like to thank all of the lenders who have graciously parted with their treasures during the run of the exhibition: Mr. Lutz Casper; the Cincinnati Museum of Art; Mr. and Mrs. D. Hayden; Dr. and Mrs. R. Hovanessian; the MORA Foundation; the Museum of Contemporary Art, Miami, Florida; Andrea Rosen; and Dr. Thomas Waldschmidt.

ACKNOWLEDGEMENTS

KRISTIN CHAMBERS, CURATOR

The catalogue accompanying this exhibition is a work of art in itself. For that, I thank art director Laurie Haycock Makela and designer David Cabianca. I have admired their work in the past and am honored that they agreed to lend their talent to the design of this catalogue. Tremendous thanks are due to Editor Larry Gilman. His comments and queries in regards to my essay truly helped me to focus my ideas and I thank him for his insight. My gratitude also goes to Michael Sorkin, who has contributed an engaging essay to the catalogue, providing additional insight into the ideas put forth by **COMFORT**.

Jorge Pardo
Artist contribution to this catalogue.

The seed for **COMFORT** came from a conversation with Matthew Ritchie in the spring of 1999. It has since evolved considerably, but I thank Matthew for prompting me to think about some of my favorite artists under new terms. Finally, I would like to offer my deepest thanks to the artists in the exhibition—Franz Ackermann, Peter Land, Sarah Morris, Gabriel Orozco, Jorge Pardo, Tobias Rehberger, Gregor Schneider, and Andrea Zittel. I have thoroughly enjoyed working with each of them. Their work continues to intrigue and inspire me and I am grateful for their attention to and enthusiasm for this exhibition.

SURVIVAL KIT.:

'SURVIVAL KIT' is a combination of *objet trouvés* in a box. The work exist in an edition of 10 examples. It consist of a wooden box containing a star telescope, a bottle of whiskey and a glas. On the box is printed the texts; 'FOR COMFORT' and 'Device for putting things into perspective'.

The idea behind the work is;

If your spouse/lover left you and you feel down: Drink a bottle of whiskey, take a look at the stars and get things back into perspective.

If you got fired from your job and you feel down: Drink a bottle of whiskey, take a look at the stars and get things back into perspective

If someone you loved died and you feel down: Drink a bottle of whiskey, take a look at the stars and get things back into perspective

If your firm went bankrubt and you feel down: Drink a bottle of whiskey, take a look at the stars and get things back into perspective.

If your house is destroyed in an earthquake: Drink a bottle of whiskey, take a look at the stars and get things back into perspective.

If you get diagnosed with a terminal illness: Drink a bottle of whiskey, take a look at the stars and get things back into perspective.

If you are told that you are a lousy dancer: Drink a bottle of whiskey, take a look at the stars and get things back into perspective.

If you get turned down by someone you would have liked to have sex with: Drink a bottle of whiskey, take a look at the stars and get things back into perspective.

If your dog died: Drink a bottle of whiskey, take a look at the stars and get things back into perspective.

If you've pissed your pants: Drink a bottle of whiskey, take a look at the stars and get things back into perspective.

If it's raining: Drink a bottle of whiskey, take a look at the stars and get things back into perspective.

If it's not your day: Drink a bottle of whiskey, take a look at the stars and get things back into perspective.

If it's not your month: Drink a bottle of whiskey, take a look at the stars and get things back into perspective.

If it's not your year: Drink a bottle of whiskey, take a look at the stars and get things back into perspective.

If this doesn't help; call me on (+45) 33 14 18 34

Love

Peter Land

THE WORLD MATERIALIZED SOMETIME IN THE 18TH CENTURY. Rationalism, industrialism, and the rising bourgeoisie meant a sudden abundance of *things,* the quantities and qualities of which could be reliably classified, measured, and valued. The world was suddenly populated with objects of desire, each with its price.

Comfort is luxury without waste—efficient luxury—and prides itself in its modesty. Luxury is excess, claims comfort; it attaches itself to authority—think Louis XIV—subverts the pleasure of the rest of us—think sumptuary laws. Luxury is enjoyment beyond normal measure, unattainable, indecent. Comfort is more Protestant, more *bourgeois.* It comes as a fair reward for labor. It is moderate, the reasonable face of luxury. Naturalized as one of life's necessities, comfort is politicized as a right.

The bourgeoisie produced a new kind of economy, based on the prospect of rising fortunes and universal dispersion of goods, all driven by Adam Smith's engine of "self-love." Mass production meant that enjoyment could be—indeed, had to be—shared. And, the huge number of objects in circulation led to an accelerated evolution in variety via the mutations of fashion and competition.

The economy of consumption made comfort valuable as both a condition *and* a commodity. Marx referred to this economic objectification as the "fetishism of commodities," a condition where everything becomes negotiable and in which labor, in particular, becomes an object—is *reified*.

THE MEASURE OF COMFORT

MICHAEL SORKIN

Along with the vast dissemination of stuff, capitalism also commodified time via the wage system. Measured and valued, productive time created its opposite: leisure time, likewise commodified. Surplus time in measurable quantities, combined with the notion that comfort was not simply something to be enjoyed but something to be bought, created a market for comfort and changed the world forever.

During the second world war, the Japanese army used the euphemism "comfort women" to describe the sex slaves used to slake its soldiers' lust during the occupation of Korea. Of course, the "comfort" was entirely one-sided. The troops' comfort was the women's nightmare, a product of cultural myopia, racism, sadism, and misogyny. But such behavior does beg the question of comfort's ethics. Comfort—distinguishing itself from luxury—lodges its ethic in resistance to excess (while maintaining luxury as its unspoken desire).

Peter Land

Faxed text from *SURVIVAL KIT,* 1998/99

Artist contribution to this catalogue.

By effacing their luxurious cruelty with the modest and honest label of comfort, the Japanese claimed their behavior normal, part of the order of things, not an aberration. The troops probably rationalized their barbarism to

themselves by claiming they were fulfilling a "natural" need: boys will be boys. Japanese commanders simply sought an outlet for their troops that would restore them to psychic normality, increase their comfort level in the artificially dehumanized atmosphere of war.

MOST OF US BELIEVE IN VICTIMLESS COMFORT.
OUR OWN CREATURE COMFORTS, FOR EXAMPLE,
OFTEN FIND THEIR ETHICAL VALENCE IN OUR CONCERN FOR OUR
FELLOW CREATURES. While our forebears were comforted by the warmth of furs and by the sight of stuffed bison heads above the mantle, our own ethics of comfort demand that we forego swaddling ourselves in the skins of our brother and sister mammals, particularly the endangered ones. Similarly, our comfort level drops at the discovery that our Kathie Lee jeans were sewn by ten-year-olds in the sweatshops of the underdeveloped world.

In this case, the ethical trumps the aesthetic, the physiognomic, and the economic, saddling these pleasures with a burden of guilt: we cannot take comfort outside our ethical comfort level. Comfort describes its own territory of judgment, which needs to be secured from ethical interference: like taste, comfort has a standard. In its effort to measure it, modernity uses relaxation as its major metric. If comfort is to be quantified, and judged in a rational way, the body is the place to get started. We know that creature comforts relax us, lower our blood pressure. Research shows how pets comfort the elderly: each stroke of the pup drops pressure a point. Comfort is the sigh we give as we sink deep in our chair, a collusion of culture and musculature. Reason makes physiognomy the architect of comfort.

12

The struggle for comfort lies in a complicated and on-going conflict between culture and the body. At the turn of the last century, American middle-class women's clothing was uncomfortable, commodifying, hierarchical: women were designed as objects of physiological and cultural comfort for men, the eye elevated as the dominant organ of discipline, not altogether unlike today. Nineteenth century home furnishings continued this aesthetic objectification; here too the beautiful was constructed from plush curves and underwire. The springs and stuffing of the Victorian era attempt to induce weightlessness in the sitter, giving comfort both as structures of support in their flirtation with the fringes of excess. Victorianism sought its halcyon of domesticity in the simultaneous celebration and repression of the idea of too much.

There are, of course, parallel histories of austerity and resistance. Shaker furniture, for example, instates the ethical not as a component but as the very criterion of comfort. The Shakers' austere designs supported sitters upright, in the moral position, conflating the simple life with the comfortable one and locating morality in both the gift of simplicity and in self-sufficient craft. Modernity refined this ethical imperative to include technology, mind over matter. Ergonomics is, *par excellence,* the technicized discipline of modern comfort, seeking to produce comfort scientifically, to make relaxation rational, even stimulating.

The Aeron Chair—designed by Chadwick and Stumpf—is widely advertised as the most comfortable in the world. Truly a machine for sitting, its comfort derives from its meticulously worked-out mechanism, exotic materials, and counter-intuitive, but lovely, appearance. A chair need no longer *look* comfortable to be so. As with an athletic shoe or an exercise machine, we assume that the comfortable aspects of the chair have been worked out by experts, that form follows function, that we are purchasing the most efficient imaginable delivery system for comfort.

Aeron offers a preferred image of the contemporary subject, who is expected to be seated, at work. But it is not simply contoured to the Protestant ethic and its moral comfort in labor, it is a modern *liberal* chair and comes in three sizes, recognizing small, medium, and large subjects. Whatever its size, though, the chair uses comfort to stimulate us to greater heights of productivity at our workplace and reinforces the status of the technological. The Aeron is the *Porsche* of the sitting classes.

The comforts of home have gone through similar evolutionary twists. The comfortable house of the turn of the century—overstuffed, overdecorated, and overdark—is something quite different from the comfortable house of modernity—sundrenched and dominated by its view, but austere in its decor and severe in its demands on behavior. While both sought to modify conduct by imaging the shape of the good life, the two visions discipline with opposing styles of comfort, one of calibrated simplicity and the other of a surfeit of stuff.

If comfort demands some degree of psychic enclosure, "home" fixes its character and degree. Our social zones of comfort are a continuing negotiation: that many of us feel most comfortable at home is, at least in part, a product of the dangers of the street and the impoverishment of the comforts of public space.

13

AS NEW MEDIA TRANSFORM THE HOME INTO BOTH THE SITE OF COMPENSATED WORK AND THE POINT OF PURCHASE FOR DOMESTIC CONSUMABLES, OUR DWELLINGS ARE INCREASINGLY CONVERTED TO BATTLEFIELDS OF THE STRUGGLE BETWEEN LEISURE AND WORK AND OF

THE RELATIONSHIP OF COMFORT TO SPACE.

The home thus continues to be a place of conflicting meanings. When, for example, a hotel advertises the comforts of home, two interpretations suggest themselves. First, that comforts are offered that are totally unavailable at (your) home: maids, room-service, vibrating beds, conceierge. Or, alternatively, that the hotel offers the zero-degree of comfort, no more than the range of things that you've left back home. This ongoing oscillation between luxury and austerity marks the dialectic of modern comfort with its dream of excess and its superego of rationality.

Comfort food is another contemporary offering of the culture of comfort. Although it generally represents the victory of memory over experience, it can be a *madeleine* mainline to childhood, mom, and the ease of irresponsibility.

Comfort food—canonically, meatloaf and mashed potatoes—evokes a bygone formula of nutrition and in this sense represents a break from rationalist calculation. It is luxurious, however, in its dietary irrationality and its groaning Norman Rockwellesque abundance. It is not an extra helping of caviar but seconds on blandness, indigestion its own ultimate measure.

A recent installment in the *New York Times'* endless series on overweight America reveals that obesity is not class-bound and is as likely to occur in the poor as in the rich. We take comfort in such news, in the democratization of excess, in its constant recalibration to embrace fatter and fatter possibilities. Too fat, too rich, too thin, too poor, the standards of comfort prove flexible in the enduring dialectic of discipline and excess that creates our ideas of comfort.

But comfort faces a bigger challenge still in the age of electronics and simulation, when the authenticity of everything is cast into radical doubt. Like a sensory version of cold fusion, the cold comfort of the simulacrum proposes to create the heat of experience from the chill of artifice and with the same prospects of success. Is it possible to enjoy virtual comfort? The aesthetic in virtuality lies in its ability to fool, Plato's old anxiety about art. But who is to be the judge of the quality and reality of our pleasure. How are we to know when we're truly comfortable?

We will still have to rely on our (increasingly fat) bodies and our susceptible brains. Of course, for millions, comfort is found in simply going with the flow. After all, if our brains continue to be the receptor, who can really say that the body is estranged? Is the genital tingle of morphed porn any less authentic than the pleasures of shared flesh? Is the curl of smoke rising from the post-coital Camel any less soothing than before? For the moment, with the simulation sciences just entering their adolescence, it's hard to say.

Certainly, many are responding, including captains of industry eager to sell us our own responses and the art-world with its own perplexity at the new. High art and architecture busily riff the vanishing forms of comfortable circumstances, recuperating the idea of comfort but viewing it through a scrim of inaccessibility. The creation of local circumstances of control and interaction, of tableaux of assembled domestic elements, of various arty mnemonics for the private, are all modes for asserting that our bodies are still the measure of the comfortable. In these practices, the authenticity of sensation is defended by locating the sources of comfort in the palpability of things, in construction, in the artistic practices of the hand, in the reality of the object that stands in front of us. Such artistic resistance succeeds by allying itself with the eccentricities of pleasure. **THE DANGER, AFTER ALL, IS NOT IN THE MEASUREMENT OF PRIVATE PLEASURES BUT IN A UNIVERSAL STANDARD, ONE COMFORT FITS ALL.**

Comfort is surely going through a crisis of authenticity based both on commodification and simulation. If the Aeron can be replaced by an electrode in the brain and mama's lasagna by a pill, *something* is put at radical risk.

Without a doubt, there's a politics here and, like any politics, this one comes down to control. Comfort represents a kind of utopia, an ideal—*a reasonable*—place to be human. And, as we increasingly become puppets to the corporate priests of pleasure and relaxation down at Comfort Central, we surrender a few more of our rights to be human, just as we surrender them to the mullahs of Madison Avenue, to the industrial-strength commodifiers of global culture, to the cadre of usurpers who seek to make our choices for us.

Again, the discourse of comfort betrays its ambivalent relation to universality. We have long sought to enjoy conflicting comforts of difference and indifference. The bourgeois version of freedom—and comfort—is obsessed with the unique product, the property that belongs exclusively to oneself. At the same time, its links to democratic politics simultaneously counterargue for single citizenship. How do you see a billion identically dressed Chinese: as deadening uniformity or as a comforting, non-competitive shared realm, in which inequality has ceased to oppress, at least sartorially. Would it work better in jeans or in black leather?

THE RISK IS THAT COMFORT MAY BECOME AN ABSOLUTE, SIMPLIFIED TO A **SINGLE STANDARD** BY THE POWER OF MASS ACCULTURATION. How long will we resist having all our comforts dictated, if not by Mao then by Martha Stewart? On the other hand, what Comfort Central has in store could be fabulous—more fun, more comfortable than anything we've been able to imagine so far. I'm skeptical but I'm willing to give that electrode a try.

BUT ONLY IF I CAN FLICK THE SWITCH.

Michael Sorkin is the principal of the Michael Sorkin Studio in New York City. He also holds posts as Professor of Architecture and Director of the graduate urban design program at New York's City College. Sorkin is the former architecture critic for **The Village Voice** and has published a number of books including **Variations on a Theme Park, Exquisite Corpse** and **Local Code.**

A PLACE TO CALL HOME
(IN SEARCH OF COMFORT)

KRISTIN CHAMBERS

THROUGHOUT TIME, man has been driven to understand and actively negotiate individual existence in relation to the larger environment. As the civilized world has evolved, seismic shifts in the status quo, such as the Industrial Revolution and the Information Revolution, which we find ourselves in the midst of today, have caused the stage on which mankind plays to shift considerably.[1] A distinctly human consequence of such societal transformations is the dramatic alteration of the spaces in which we live, and the resulting shift in our experience in relation to our surround, be it universe, city, or home. The Industrial Revolution, for example, precipitated a transition from production based in the home, small workshop, or farm, to mass manufacturing centered in the factory. As a result, vast numbers of people necessarily migrated from small, comfortable communities into the crowded, often grim, urban environments that now housed the centers of industry.

Similarly, today we are faced with a dynamic shift brought on by the onslaught of new information technologies and the "virtual revolution." Information is available on an astonishing scale and (virtual) access to people and places from all corners of the globe is at our fingertips. The Internet has reduced the physical reality of the world to a confusing conglomeration of digital postcards and fanciful web pages, and the speed afforded by technology in the 21st century propels us increasingly faster through our environments. Advances in computer technology have at once connected the world as never before and fragmented our physical experience of our environments, complicating fixed notions of reality. While these technological advances have obvious merits, they

18

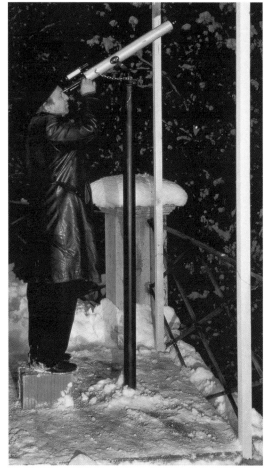

FIGURE 1 Peter Land

TELESCOPE/STOPOVER, 1998

Installation including telescope, bottle of whiskey,
and drinking glass

Photo courtesy of Galleri Nicolai Wallner, Copenhagen

have also served to distance, even isolate, us from the physical reality of the world. Today it is possible, even preferable, to conduct a majority of one's business and personal dealings without ever leaving home. As our world continues to develop, it becomes intriguing to consider how models of comfort and routines of daily life are changing to address the needs of the self within an increasingly fragmented and virtual world.

As critic Jonathan Crary explains, "One of the crucial paradoxes of 'globalization' is this: the greater the technological capacity for connection, for speed, for exchange and circulation of information, the more fragmented and compartmentalized the world becomes."[2] It follows then, that as the world becomes more and more expansive, understanding our relationship to our immediate environment becomes ever more difficult and, at the same time, ever more vital.

The increasingly digital nature of modern society is in essence reducing the world to an easily consumable series of ones and zeros, devaluing the tactile and dramatically altering our corporeal experience of the world. Drawing on the premise that "art gives us back what technology takes away,"[3] **COMFORT: RECLAIMING PLACE IN A VIRTUAL WORLD** examines how contemporary artists from around the globe fill a perceptual void created by the virtual and manage their place in the continually shifting environment of the modern world. Peter Land (Denmark), Franz Ackermann (Germany), Sarah Morris (England and USA), Gabriel Orozco (Mexico and USA), Tobias Rehberger (Germany), Andrea Zittel (USA), Jorge Pardo (USA), and Gregor Schneider (Germany) each use the practice of art-making to reclaim what has been lost at the hands of globalism and technological advances: subjectivity and intimacy. **THE WORK OF THESE ARTISTS COVERS A WIDE SPECTRUM OF CONCERNS, RANGING FROM THE UNIVERSAL TO THE PERSONAL,** OFFERING BOTH CONCEPTUAL AND PRACTICAL SOLUTIONS TO FINDING COMFORT IN A RAPIDLY CHANGING WORLD.

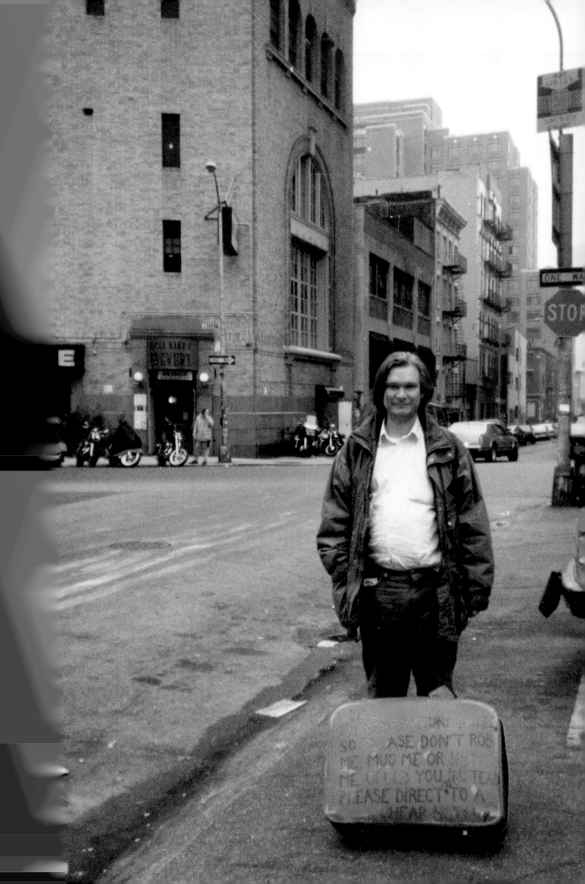

ARMED WITH A BOTTLE OF WHISKEY and a wicked sense of humor, Peter Land tackles weighty, existential questions with characteristic self-deprecating wit. While at one time the cosmic universe was abstract and perhaps easily regarded as having little direct impact on daily life, today we find ourselves concerned with global warming, the ozone layer, and the looming threat of a falling asteroid, and overwhelmed by the possibility of space travel and other life-forms sharing our solar system. Drawing on an enduring concern with the absurdity of human life, Land's work in **COMFORT** tackles the big question of what meaning lies behind one's life in a world that is growing so fast that the individual is becoming increasingly less significant.

Land has always been, as he says, ". . .deeply fascinated, and at the same time repulsed by people who seem to have a clear sense of purpose in their lives. People who can distinguish between what's important, and what's unimportant, and refer to their surroundings in terms of their place in the 'Big Picture' . . .I envy these people the stubbornness with which they maintain the firmness of their beliefs, the orderliness of their lives, their ability to focus themselves in this world. A world that seems utterly confusing and disorderly."[4]

Like his artistic soul-mate, Bruce Nauman, Land's slapstick exposes the absurdity and senselessness that underlie human existence. Experimenting with photography, video, performance, installation, painting, and drawing, Land—perhaps futilely—attempts to uncover his purpose as an artist and as a citizen who "takes up a certain space in this world." Land's central work in **COMFORT** is the double video projection *The Staircase* (1998) *PL. 1.* Set in a darkened room, the piece features two video loops; in one a man tumbles down an endless flight of stairs with no beginning and no end. This image is juxtaposed against a projection of the infinite cosmos. Never one to veer from public humiliation, Land himself is the unfortunate fool spilling down the stairs, suspended in a state of "existential limbo."

PETER LAND

A seemingly unrelated series of photographs, *Hi, I am new around here. . .* (1996) *FIG. 2*, captures Land shelving such cosmic concerns in favor of simply trying to make his way through the urban jungle that is New York City. The same anxiety and uncertainty demonstrated in *The Staircase,* however, accompany him through the streets of Manhattan. An insecure tourist, Land carries a suitcase—stenciled with the phrase "Hi, I am new around here, so please don't rob me, mug me or kill me. Could you instead please direct me to a cheap hotel?"—like a security blanket. One has the sense that once the cheap hotel is identified, Land will hole up to hide from the world.

FIGURE 2 Peter Land

HI–I'M NEW AROUND HERE SO PLEASE DON'T ROB ME, MUG ME OR KILL ME. COULD YOU INSTEAD PLEASE DIRECT ME TO A CHEAP HOTEL (NEW YORK CITY), 1996

Color photographs

Photo courtesy of Galleri Nicolai Wallner, Copenhagen

Although *The Staircase* and *Hi, I am new around here. . .* offer a bleak view of modern life, Land does not leave the viewer stranded, feeling hopeless and

questioning the point of existence. Instead, he invites the viewer to actively consider his own place in the world. The installation *Everybody Is a Star* invites the viewer to drink a glass of whiskey, listen to space-themed pop songs, and lose himself in a glow-in-the-dark chart of the cosmos. But it is *Survival Kit* that is perhaps Land's greatest contribution to coping with the existential dilemma. Here, Land offers a "device for putting things into perspective": a wooden box containing a telescope, a bottle of whiskey, and a glass, with a set of instructions including these, and other, words of wisdom: "If your house is destroyed in an earthquake: Drink a bottle of whiskey, take a look at the stars and get things back into perspective."[5] Rather than providing answers, Land embraces man's fundamental inadequacies and shares his own solution for coping.

FIGURE 3 Peter Land

STEP LADDER BLUES, 1995

Video stills, 7 minute video

Photos courtesy of Galleri Nicolai Wallner, Copenhagen

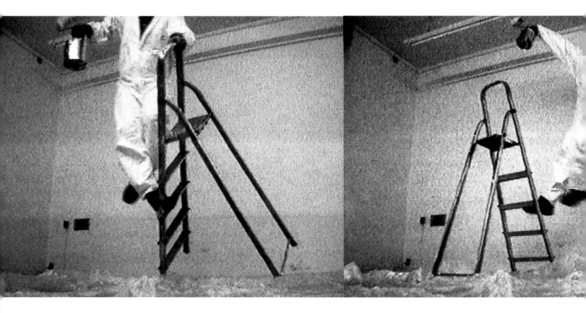

"THE WHOLE LIFE OF THOSE SOCIETIES

IN WHICH MODERN CONDITIONS OF PRODUCTION PREVAIL

PRESENTS ITSELF AS AN IMMENSE ACCUMULATION OF SPECTACLES.

ALL THAT ONCE WAS DIRECTLY LIVED HAS BECOME MERE REPRESENTATION." [6]

This thesis, posited by Guy Debord in 1967, has only increased in relevance in the decades since. Among the most prominent of those writers, artists, and theorists who joined under the rubric of the Situationist International, Debord and his followers confronted the effects of an increasingly capitalist society on lived experience. At the core of the Situationist's doctrine was the belief that through the "spectacle" of the modern world, individual experience was being replaced by collective experience mediated by news, advertising, and the entertainment industry. Additionally, it was their belief that the urban plan of a city, with streets mapped to lead foot-traffic to key sites, was also dictated by capitalist doctrine. In essence, the way one viewed and experienced the world was decided for one by the "capitalist machine."

With the technological advances of the past few decades, mediated experiences are even more pervasive. The way we view the world today is unalterably influenced by the same spectacle that concerned Debord and his followers: one might even argue more so, given the added factor of the ubiquitous Internet, which not only intrudes on primary experience, but often replaces that experience altogether. Among the methods the Situationists advocated as a means to reclaim meaningful social interaction within the urban environment was the *dérive,* in which "one or more persons. . . drop their usual motives for movement and action. . . and let themselves be drawn by the attractions of the terrain and the encounters they find there." [7]

Following the historical lead of the Situationists, Gabriel Orozco, Franz Ackermann, and Sarah Morris offer their own versions of the dérive. By disrupting the traditionally accepted narratives of the city inscribed by urban planning and the spectacle of the media, each offers a unique approach to reclaiming individualistic experience of public space in an urban environment.

GABRIEL OROZCO WAS BORN IN MEXICO, spent summers in both the Soviet Union and Cuba, and currently lives half the year in Mexico and half in New York City, when he is not traveling the circuit of international exhibitions, art fairs, and biennials that have come to characterize the contemporary art world. At the heart of Orozco's varied artistic output—including sculpture, drawing, photography, video, and installations—lay concerns about the mundane, the everyday, and the social construction of space and time. Orozco offers a personal record of his life and his environment through work that is drawn directly from his immediate experience of the world. He focuses a magical eye on the overlooked, the detritus of the urban street and, by extension, on the millions who have walked over its cracked pavement. By translating the city with minimal intervention, Orozco allows the world to speak for itself.

Through subtle interventions, Orozco deftly focuses his (and our) eye on the simple beauty of the world, moving beyond the surface, beyond the obvious, to examine the *lived* city. An early piece, *Yielding Stone* (1992), provides perhaps the most literal example of his interest in the lived city. Orozco fashioned a plasticine ball whose size was determined by his own weight. The ball was then rolled around the city of Monterey, Mexico. As suggested by the title, whatever detritus lay in the path of the ball stuck to the plasticine. The resulting sculpture is a compact, abstracted picture of Orozco's travels through the city.

GABRIEL OROZCO

Orozco's other sculptures and installations are made from material scavenged from city dumpsters and streets. These, and his unassuming photographs of city sites, illuminate the poetry of the everyday world often over-looked in favor of the spectacle of monuments, architectural triumphs, billboards, and store windows that have come to define the commercial, scripted landscape of the urban environment. In *Island Within an Island* (1994) FIG. 5,

FIGURE 4 Gabriel Orozco
FROM GREEN GLASS TO FEDERAL EXPRESS, 1997
Video still
Photo courtesy of Marian Goodman Gallery, New York

for example, Orozco offers a miniature version of the imposing Manhattan skyline. The photograph documents an ephemeral "sculpture" made on the spot by Orozco out of litter and leftover pieces of board found on the street. Orozco's modest, scaled-down version of Manhattan personalizes the city for the artist and the viewer, neutralizing the anxiety often caused by the city's overwhelming size.

Another document of Orozco's experience of an environment, as well as a literal realization of the Situationist dérive, is found in films with such titles as *From Dog Shit to Irma Vep* (1997), *From Flat Tire to Airplane* (1997), and *From Green Glass to Federal Express* (1997) FIG. 4. Shot throughout a typical day in, as he describes them, "very ordinary urban settings," these films allow Orozco to collapse the expansive, sometimes impersonal city into only the people, places, objects, and sites he finds personally interesting.

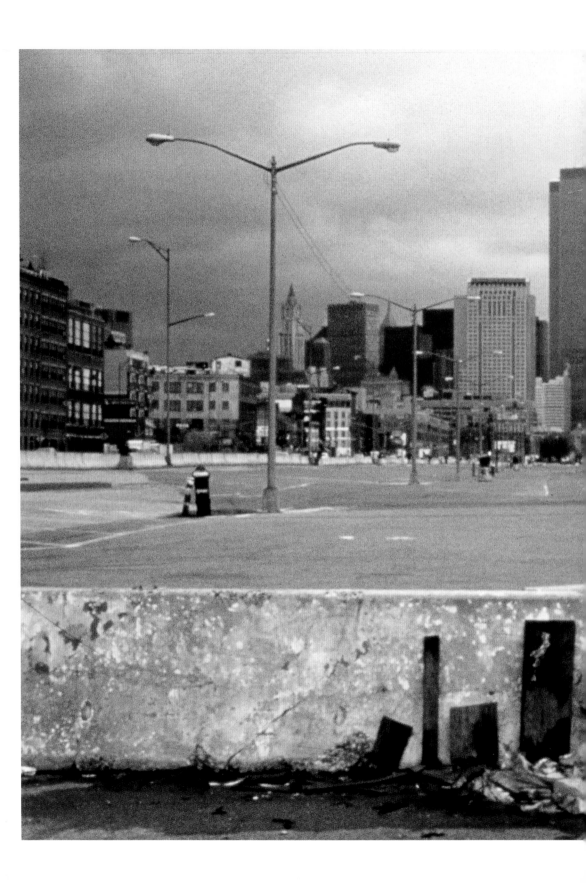

FIGURE 5 Gabriel Orozco
ISLAND WITHIN AN ISLAND, 1993
Cibachrome photograph
Photo courtesy of Marian Goodman Gallery, New York

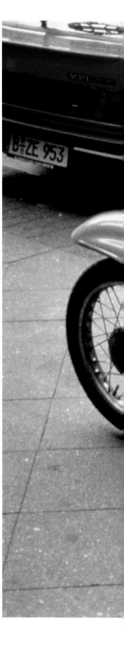

FIGURES 6, 7, 8 Gabriel Orozco
UNTIL YOU FIND ANOTHER YELLOW SCHWALBE, 1995
Set of 40 c-prints
Photos courtesy of Marian Goodman Gallery, New York

"Walking down, say Sixth Avenue, I'll suddenly see something that intrigues me—a plastic bag, a green umbrella, an airplane tracing a line in the sky. That's how I get started. . . I move from one thing to another, and in the film they'll be situated next to each other or happen right after one another, although there may be ten or twenty minutes between them in reality. . . For example, the tape I like the most, *From Dog Shit to Irma Vep,* traces a series of connections between two things: a piece of dog shit I saw on the street at 10:45 a.m and this beautiful Chinese actress whose face I found on a poster at 4:45 p.m."[8]

28

Letting the genuine city serve as his guide, Orozco condenses the seemingly incongruous fragments encountered throughout a day, offering viewers a glimpse into his visual vocabulary and subjective experience of the urban environment.

This notion—finding a thread to link what is often a disjointed and over-whelming experience of the physical environment—is a recurring theme in Orozco's work. *Until You Find Another Yellow Schwalbe* (1995) FIGS. 6, 7, 8, for example, is a series of 40 color photographs documenting all the instances when Orozco encountered a yellow motorcycle similar to his own while traveling the vast urban territory of reunified Berlin. The vehicle can be seen as a symbol of consumer culture and universal accessibility, similar to the Volkswagen (literally, the "people's car"). In commemorating all the instances of this occurrence, Orozco once again suggests a means of feeling at home in the world. The artist is linked with an endless number of other Schwalbe owners, allowing him to collapse the once segmented city into a place full of potential friends.

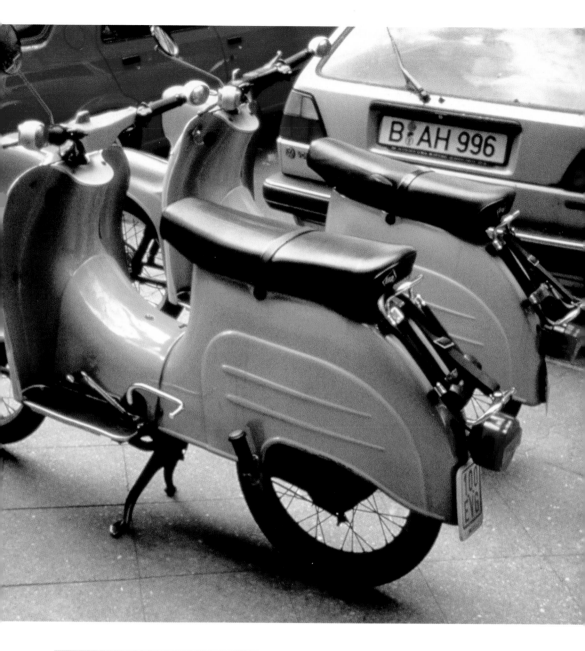

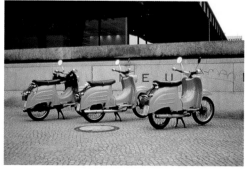

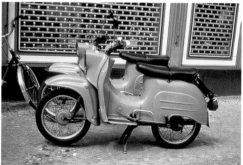

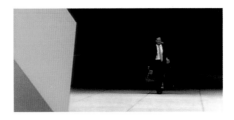

FIGURES 9, 10 Sarah Morris

*Film stills from **MIDTOWN**,* 1998

16mm/DVD, 9 minutes 36 seconds, edition of 3

Photos courtesy of the artist and Jay Jopling/White Cube, London

FIGURE 11 Sarah Morris

MIDTOWN–ARMITRON (MADISON SQUARE GARDEN), 1999

Gloss household paint on canvas

Courtesy of MORA Foundation. Photo courtesy of

Friedrich Petzel Gallery, New York

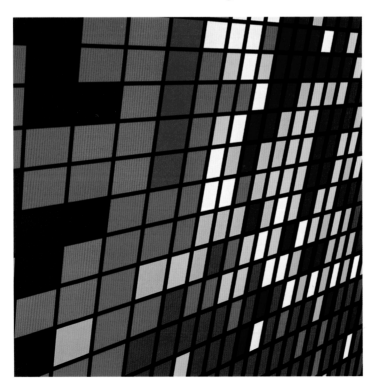

IN RECENT YEARS, SARAH MORRIS HAS TURNED HER ATTENTION from the symbolism inherent in language and pop icons to mediating the iconography of the urban street. The shift from Pop-inspired text paintings and canvases featuring women's legs clad in designer hosiery and fashionable high-heels to paintings and short-films inspired by the mass of urban information is not as vast as it may seem. In both bodies of work, Morris' spotlight is focused squarely on evocative symbols, forcing those who view her work to recognize that one's experience of the world, although individual, is also predicated on a shared system of signs and symbols whose meanings are culturally predetermined. By co-opting the "scripted" experience of a city and filtering that experience through her subjective lens, Morris reveals the constructs of our knowledge and offers new possibilities for a unique appreciation of the world.

Drawing on the architecture and activity that defines such quintessentially American cities as New York, Las Vegas, and Washington, D.C., Morris' short films—*Midtown* (1998), *am/pm* (1999) and *Capital* (2000)—are, as she explains, "based on how I go about living day to day, circulating through situations and constructing a path out of visual fragments."[9] While on their surface the films appear to be documentary, Morris carefully orchestrates her shots to foreground the question of reality versus representation. Her choice of subject matter—familiar shots seemingly taken from stock footage used in any modern day newscast, feature film, or urban drama—may seem banal, but that is precisely the point. The images Morris draws on are common and recognizable, but also iconic and loaded with meaning.

SARAH MORRIS

Her most recent film, *Capital (Washington D.C.)* [2000], for instance, was filmed in the nation's capital during the months prior to the 2000 presidential election. A counterpoint to *Midtown,* which walks the viewer through the maze of Manhattan streets, and *am/pm,* which journeys down the lively and extravagant Las Vegas strip, *Capital* exposes the disparity between the official Washington—characterized by the layout of the city, its official architecture, and the power brokers who work within its hallowed halls—and the off-the-record version.

In making this film, Morris was interested in the disparity between the city's very ordinary veneer and its official blueprint. Footage filmed in such emblematic locations as the White House, Pentagon, and offices of the Washington Post is seamlessly mingled with footage of the "real" city, exemplified by sites such as the post office, McDonald's, and unremarkable city streets. Indeed, the urban plan of the capital sets the stage for a carefully choreographed experience, orchestrated to reflect the city's authority. Walking the carefully gridded streets of the capital, the visitor experiences contrived moments of awe, such as the view of the Washington Monument from the open grass of the Mall or of the Capitol Building from the city center.

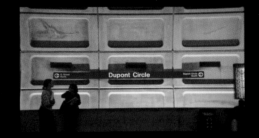

 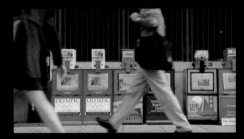

 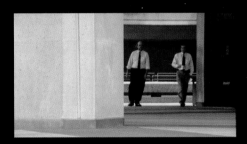

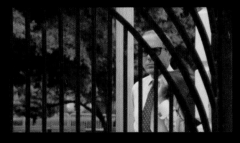 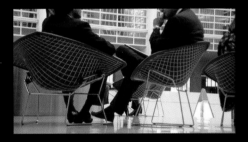

FIGURES 12-23 Sarah Morris

Film stills from **CAPITAL**, 2000

16mm/DVD, 18 minutes 18 seconds

Photos courtesy of the artist and Jay Jopling/White

Cube, London. Artist contribution to this catalogue.

Ordinary citizens to legislators with the fate of the nation in their hands, all pass through Morris' frame; undirected, they go about their daily activities. Like the buildings and the city in which they work, these characters—be they everyday office workers or the President of the United States—are emblematic of the narrative of the city.

Seeing such quintessential scenes as a convention-and-visitors-bureau shot of the Washington Monument, a CNN-style image of the Press Secretary in front of a White House microphone, or a homeless man on Pennsylvania Avenue taken out of their traditional contexts draws attention to the apparatus that constructs our knowledge of a city. Morris underscores how we are attracted or manipulated by iconic images, and in doing so ultimately disrupts the traditionally accepted character and experience of the archetypal city.

For each city documented in film, there exists a corresponding series of paintings in which Morris refashions segments of modern urban office buildings into colorful, eye-catching abstractions. "The paintings are another level of processing," she explains. "A universe of simplification through the recognition of the effects that result from images being circulated and consumed."[10] Focusing on the sleek facades of corporate headquarters and on the geometric designs and patterns created by neon lights washing over buildings and other electric signage of the city, **THE PAINTINGS ARE EVOCATIVE OF URBAN SPECTACLE.** However, Morris injects these urban archetypes with her own content. Like the films, the paintings are personal syntheses of urban reality derived from Morris' own experience. Morris is, she says, "interested in exposing the comfortable, almost familiar relationship that most people have to corporate architecture."[11] Like the fictional scenarios set up by the films, Morris' paintings present a set of effects that upset the presumed meaning behind the loaded original.

FIGURE 24 Sarah Morris
NEON—NITROGRILL, 2000
Gloss household paint on canvas
Photo courtesy of Jay Jopling/White Cube, London

FIGURE 25 Sarah Morris
NEON—RUMJUNGLE (ORANGE) [LAS VEGAS], 1999
Gloss household paint on canvas
Collection of Dr. Raffy and Vicki Hovanessian, Chicago IL
Photo courtesy of Jay Jopling/White Cube, London

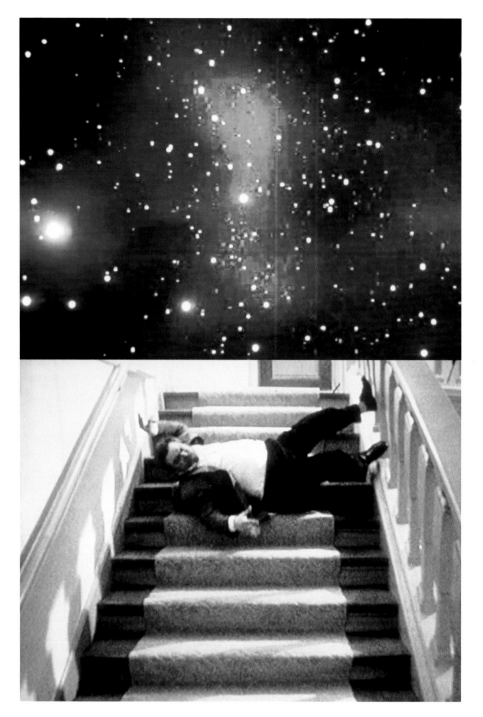

PLATE 1 Peter Land
THE STAIRCASE, 1998
Double video projection, 5 minutes
Courtesy of Galleri Nicolai Wallner, Copenhagen

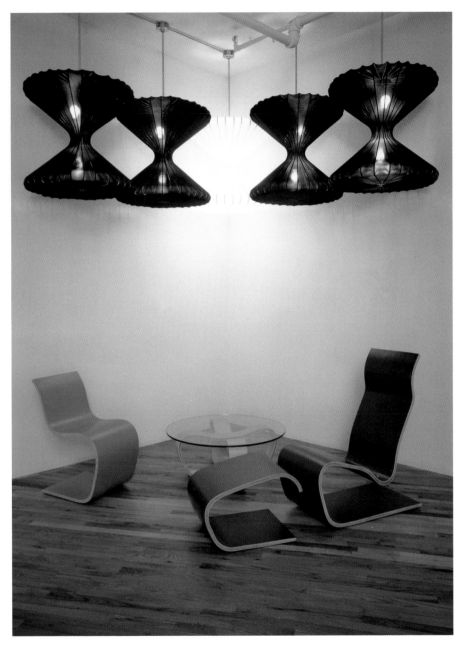

PLATE 2 Jorge Pardo
HALLEY'S, IKEYA–SEKI, ENCKE'S, 1996
Mixed media
Photo courtesy of Friedrich Petzel Gallery, New York
and neugerriemschneider, Berlin

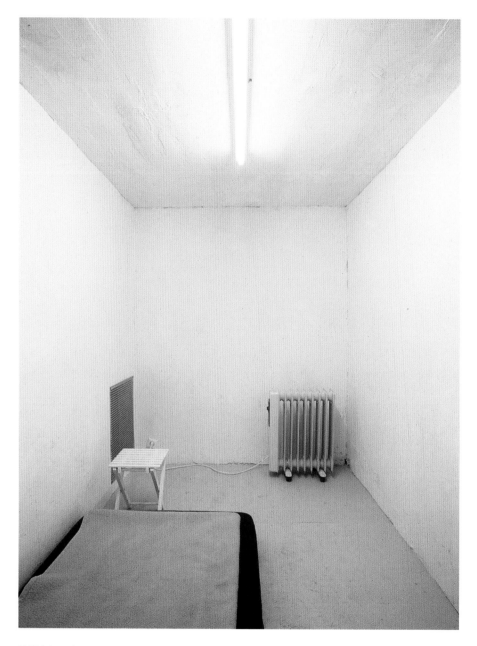

PLATE 3 Gregor Schneider

TOTALLY ISOLATED GUESTROOM, UR 12, 1995

Mixed media installation

Collection of Dr. Thomas Waldschmidt, Cologne, Germany

Photo courtesy of Galerie Luis Campaña, Cologne

PLATE 4 Sarah Morris
FLAMINGO HILTON (LAS VEGAS), 2000
Gloss household paint on canvas
Collection of Mr. and Mrs. David Hayden
Photo courtesy of Jay Jopling/White Cube, London

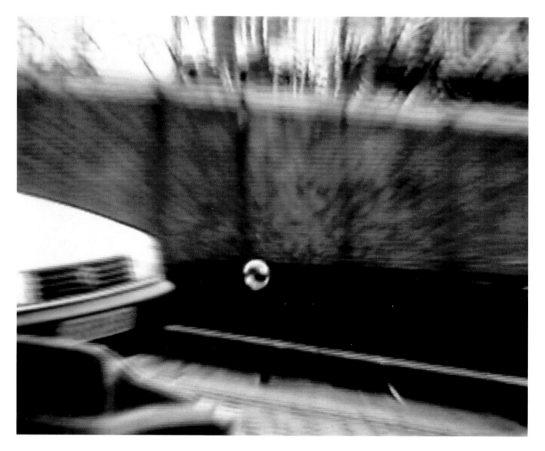

PLATE 5 Gabriel Orozco

FROM FLAT TIRE TO AIRPLANE, 1997

Video still, 44 minutes 40 seconds

Photo courtesy of Marian Goodman Gallery, New York

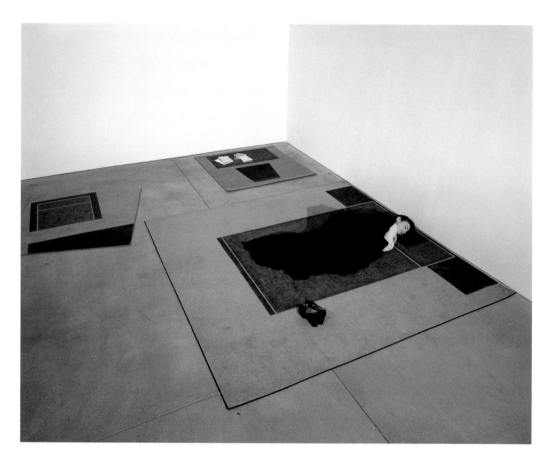

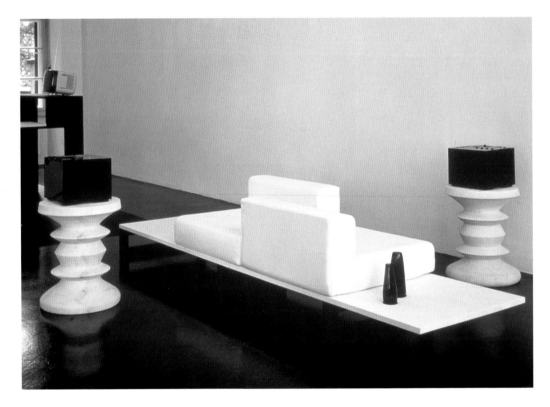

PLATE 7 Tobias Rehberger

NO NEED TO FIGHT ABOUT THE CHANNEL. TOGETHER.

LEANT BACK. From *FRAGMENTS OF THEIR PLEASANT*

SPACES (IN MY FASHIONABLE VERSION), 1999

Seats, tables, television monitors, carpet

Photo courtesy of Friedrich Petzel Gallery, New York

and neugerriemschneider, Berlin

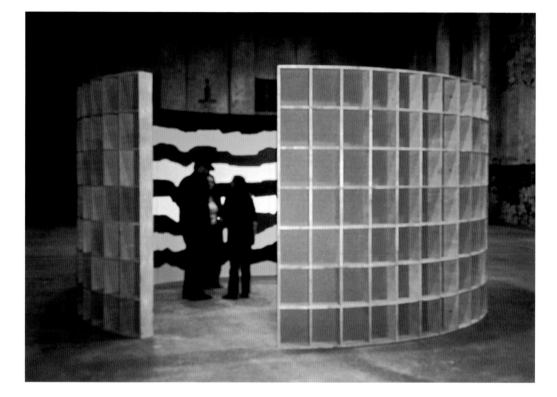

PLATES 8, 9 Franz Ackermann
UNTITLED (JANIS JOPLIN), 2000
Mixed media installation
Photo courtesy of neugerriemschneider, Berlin

IN TODAY'S TOURIST WORLD, DRIVEN BY POPULAR WEB PAGES and "Lonely Planet" books that offer commercial distortions of actuality, architectural sites define their corresponding landscapes for travelers who jet from city to city and, within each city, from landmark to landmark. India is synonymous with the Taj Mahal; Berlin with the Reichstag and Brandenburg Gate; Paris with the Tour d'Eiffel. As Raimar Stange explains in a recent catalogue accompanying an installation by Franz Ackermann, "Modern travel—one could even to an extent include the use of mobile phones, the Internet and e-mail—appears less as a (cultural) educational process and rather as its precise opposite, the consequences of which may be no less than the final loss of the feeling of place and time, and the triumphal march of the simulacrum."[12] In other words, we no longer learn from a unique experience of the city, but from the myriad representations of the city in other media.

Ackermann reclaims the city from this fate and offers it as the location for a critical and idiosyncratic experience. For him, the city is not a site for idle reception, but is instead a place of sheer activity, full of energy and endless possibilities. Like Orozco, Ackermann is often described as one of a new generation of "nomadic artists" who tour the circuit of international exhibitions. Ackermann's studio is the world—or, more precisely, hotel rooms and gallery spaces located in major metropolitan centers around the world. These spaces, interchangeable from city to city, offer a neutral environment in which Ackermann reflects upon the city in which he has just arrived, those from which he has just come, and those to which he will soon travel.

FRANZ ACKERMANN

The nucleus of Ackermann's work over the past decade is composed of a library of suitcase-sized "Mental Maps" drawn in hotel rooms while on the road and a series of large, bold paintings called "Evasions." In direct contrast to the objective, precise maps that are the traveler's crutch,

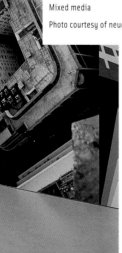

FIGURE 26 Franz Ackermann
Installation view of *HAUS DER SEHENSWÜRDIGKEITEN*, 1999
Mixed media
Photo courtesy of neugerriemschneider, Berlin

Ackermann's abstracted "maps" combine the artist's experience of the urban environment with the intense emotion that only the energy of the city can evoke. These "subjective geographies" are bold and active, translating the chaotic experience of vision in a crowded city into a pleasing abstract canvas that is "emotionally specific rather than physically accurate."[13]

According to Marcella Beccaria, Ackermann's "Mental Maps" are " a personal orientation system."[14] Combining abstracted veins of color with figurative representations of houses, buildings, towers, and landscapes, the maps are reminiscent of the view out of an airplane window, injected with memories from Ackermann's travels.

A fan of the raw, do-it-yourself ethos of the punk rock movement, and greatly influenced by Situationist philosophy, Ackermann harnesses the energy of the

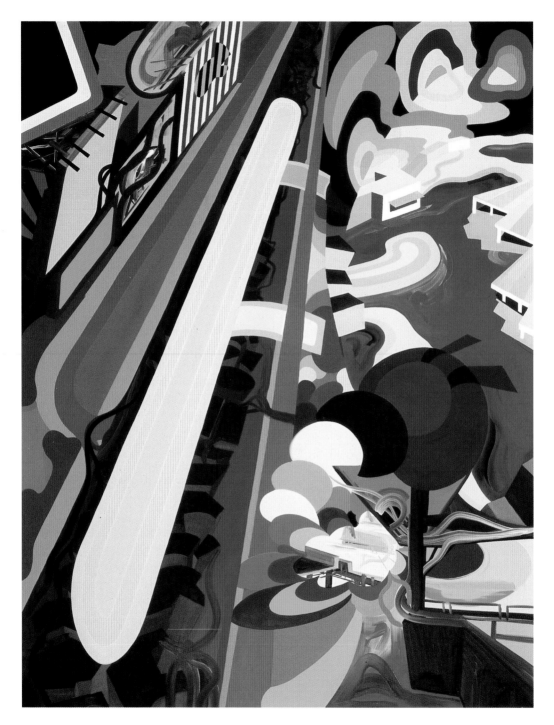

FIGURE 27 Franz Ackermann

FROM SUBWAY TO PARADISE, 1999

Oil on canvas

Photo courtesy of neugerriemschneider, Berlin

Sex Pistols, the dynamism of the city, and the politics of Debord to create his paintings and installations. Unlike his delicate, small-scale drawings, Ackermann's "Evasions" are as exhilarating, engaging, and overwhelming as the city itself. Produced in his Berlin studio, paintings such as *Abschied auf See* (2000) FIG. 29, mingle trippy, psychedelic colors with loose **REPRESENTATIONS OF MODERN BUILDINGS, BUSY INTERSECTIONS, GLASS FACADES, GRASS, CONCRETE, WATER, DRAMATIC CLIFFS, AND THE INEVITABLE END OF THE WORLD.** The world described in Ackermann's paintings—like that of Orozco and Morris—is an antidote to the flattened version presented in the media and through the internet. Ackermann's city is intense, chaotic, and fragmented, but in harnessing this energy and dissonance he celebrates the endless possibilities offered by the unmediated city.

In many ways, Ackermann's most definitive work is an editioned poster created for the Stuttgart-based publisher Revolver. Boldly entitled "Map of the World," the poster combines elements of all of Ackermann's travels—his paintings, drawings, and photographs of major urban centers around the world—to create a continuous *über*-city. Complete with a legend of symbols delineating the usual points of interest (train stations, hotels, and museums) as well as atypical "incidents," military airports, and "view points," the map is ostensibly Ackermann's version of the typical tourist map. But in Ackermann's map of the world, museums, hotels, and parking lots are situated within what appears to be a war zone complete with fiery explosions, and "points of interest" are denoted in seemingly barren areas of the collage. Ackermann manipulates the constructs of the tourist map to present his account of the world, lumps and all.

47

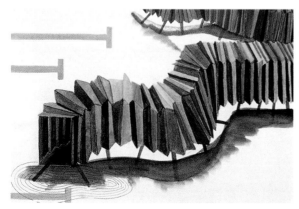

FIGURE 28 Franz Ackermann
UNTITLED (PACIFIC #2: SEAT 52 A AGAIN),
1998
Ink on paper
Photo courtesy of neugerriemschneider, Berlin

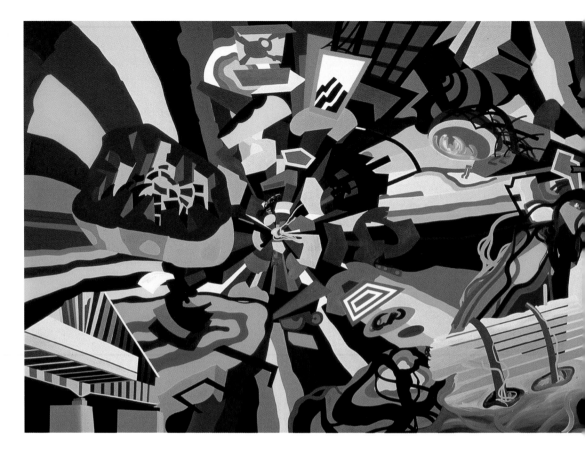

The central image in Ackermann's poster—a photograph of the "Monument to the Discoveries" in Lisbon, Portugal—speaks to the artist's abiding interest in travel and exploration. The monument, built in 1960 to mark the 500th anniversary of the death of Henry the Navigator, commemorates the explorers who were responsible for the "Portuguese Age of Discovery," an astonishing period of exploration and conquest. In many ways, this image provides a key to all of Ackermann's work. Like the hundreds of explorers whose travels uncovered the modern world, Ackermann is fueled by a steadfast passion for the unknown. Ackermann's "Mental Maps" and "Evasions" offer the artist a means to translate his discovery and appreciation of the world into distinctive works of art that, as these terms imply, offer the artist, and by extension the viewer, a means of invigorating escape, providing a dynamic space to dream of the world that awaits.

FIGURE 29 Franz Ackermann

ABSCHIED AUF SEE, 2000

Oil on canvas

Installation at the Castello di Rivoli. Photo courtesy

of Castello di Rivoli and neugerriemschneider, Berlin

Photo: Paolo Pellion

FIGURE 30 Franz Ackermann

UNTITLED (PACIFIC #1: EVENT CITY), 1998

Ink on paper

Photo courtesy of neugerriemschneider, Berlin

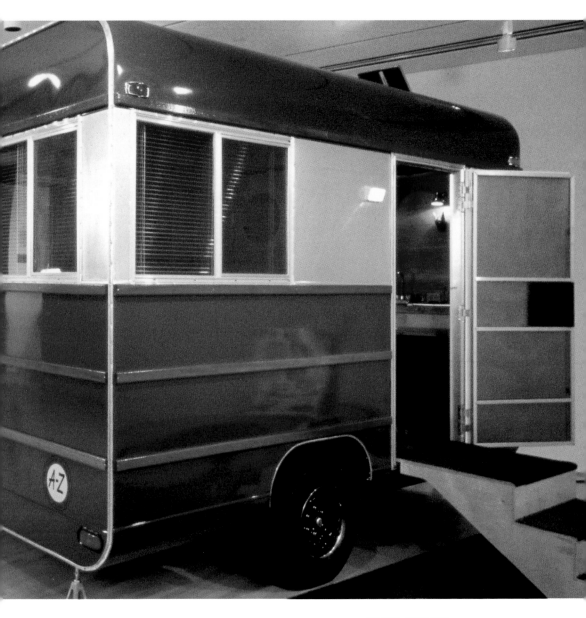

FIGURE 31 Andrea Zittel
A-Z ESCAPE VEHICLE, 1996
24-foot travel trailer
Photo courtesy of Andrea Rosen Gallery, New York

SEEKING A RETREAT FROM THE CHAOS OF THE CITY and a site for tapping into the virtual world, people are spending more time in the home than ever before. Video-conferencing, cell phones, laptop computers, and the Internet have precipitated a shift from simply "working at home" to working in a "home office." Increasingly people are streamlining their homes to serve as full-service centers for work, retreat, and relaxation. Tobias Rehberger, Andrea Zittel, and Jorge Pardo combine art, architecture, and design to improve their quality of living by creating more comfortable, even utopic, interior environments that addresses the physical, psychological, and social needs of the inhabitant.

In recent generations, the intersection of art, architecture, and design has provided a fertile ground for contemporary artists looking for new ways to represent subjective reality. Like the artists of the early 20th century Dutch movement de Stijl, who believed in utopic style and a fusion of art and life, Zittel, Rehberger, and Pardo apply the values of art to everyday objects. But unlike the adherents of de Stijl's austere aesthetic, which rejected the inclination of the individual, subjectivity is paramount for these artists. Offering simple responses to the complexities of modern life, Rehberger, Zittel, and Pardo construct new models of intimacy and function, highlighting the role that art can play in making the world more familiar and human.

OVER THE PAST DECADE, ANDREA ZITTEL has couched her artistic process within the structure of a cottage industry, "A-Z Administrative Services." Throughout her career, Zittel's work has directly addressed the **ANDREA ZITTEL** artist's personal need, as well as that of her collectors, for comfortable, highly functional dwelling spaces. Her line of travel trailers, furniture, and accessories is designed to focus on perfecting the organization of life by combining notions of comfort, order, and aesthetics. According to Zittel, her environments "express the passionate American desire to structure one's existence in order to reconcile life's intrinsic complexity." As one advertising brochure-cum-exhibition catalogue, "A-Z for You, A-Z for Me," explains, ". . .personal exploration. . . private desires into universal truths. . . freedom and security. . . the solution in my life. . . you'll like it as much as I do. . ."[15]

Zittel's desire to make furniture sprang initially from necessity. Confronted by the constraints of a small Manhattan storefront and the army of animals used for her earlier work, "Breeding Units,"[16] Zittel envisioned a single furniture unit that would be comfortable, streamlined, and would satisfy all of her living needs within a compact area. The first "Living Unit[s]," have been described by the artist as "a little nucleus of perfection which could be transported to comfort and protect me no matter what sort of larger environment I might live in."[17] Since then, the "A-Z Administrative Services" line has grown to include custom-designed living units, uniforms, travel trailers or "escape vehicles," and household objects that liberate the user from the stress of clutter, decision-making, and aesthetic pressures.

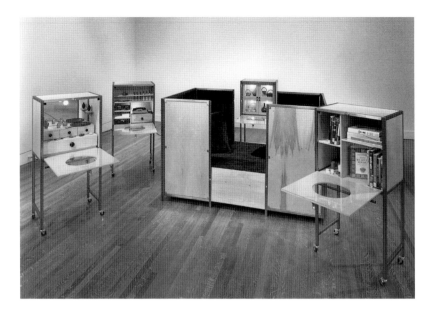

FIGURE 32 Andrea Zittel

A-Z COMFORT UNIT, 1994

Mixed media

Collection of the Cincinnati Art Museum. Gift of RSM Co.,

by exchange. Photo courtesy of the Cincinnati Art Museum

A-Z Comfort Unit (1994) *FIG. 32*, offers the ultimate in comfort, ease, and style. Zittel "love[s] this unit," which is made up of five segments, "because it sets up a scenario of never having to leave bed again. . . my fear/fantasy of being totally safe, comfortable and then completely helpless."[18] The centerpiece of the unit is a couch/bed, which is surrounded by four ancillary units (on castors for ease of arrangement). These compact units proffer a library of books, a kitchenette outfitted with dishes and teapots, a home office with telephone, pens, and paper, and a vanity housing makeup, perfumes, and a mirror. Each can be rolled up to the side of the bed according to the occupant's needs of any particular moment. With all of one's desires an arm's reach away, the lodger never has to leave the comfort and security of the cocoon-like bed. Like all of Zittel's furniture designs, the Living Unit exists in the gray area between absolute freedom and strict security.

Prior to creating the *Comfort Units*, Zittel created a line of *A-Z Carpet Furniture* (1995) *PL. 6*, objects intended as the perfect means to optimize a small amount of living space. Unlike the *Comfort Units*—which, although compact and streamlined, consume a certain amount of floor space—the carpets could hang on the wall and be laid on the floor when needed to structure a specific activity such as working, dining, or sleeping. *Bed with Two Nightstands,* for example, is a stylish eight-foot-square wool carpet with the shadow of a bed and two nightstands blocked out with carpet dye in designer colors. When placed on the floor and accessorized, the carpet serves to delineate the user's bedroom.

Other products from A-Z Administrative Services include a line of trailers used to achieve ultimate escape from the hustle-bustle of the modern world. Interested in creating microcosms that offer a totally "controllable universe" for the user, the *Escape Vehicles* (FIG. 31), as the trailers are called, contain complete living spaces customized by their owners to provide all the needed amenities. Zittels' *A-Z Deserted Islands* take the notion of escape one step further. These fiberglass islands are a cross between a boat, travel trailer, and actual island. Zittel planned to market them as "an individualized experience of isolation within a safe and comfortable environment."[19] The most recent line to emerge from A-Z Administrative Services is Zittel's *A-Z Time Trials,* which provide the ultimate escape from the pressures of the modern world— an escape from the constraints of time itself. *Timeless Chamber,* for example, is a "comfortable, lightproof and soundproof living environment, a vacation from the 'dictates of externally exposed time.'"

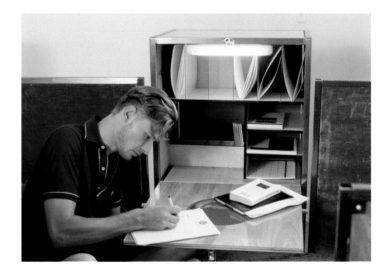

FIGURE 33 Andrea Zittel

A-Z LIVING UNIT I, 1994

Mixed media

Photo courtesy of Andrea Rosen Gallery, New York

COMFORT, PROTECTION, SHELTER

Office

Vanity

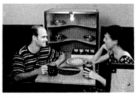

Dining

ISOLATION, INTIMACY, FANTASY

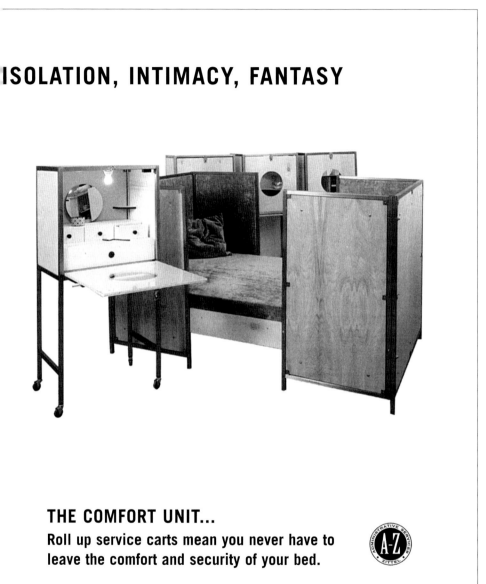

THE COMFORT UNIT...
Roll up service carts mean you never have to leave the comfort and security of your bed.

FIGURE 34 Andrea Zittel

Modified layout from ANDREA ZITTEL, SELECTED SLEEPING ARRANGEMENTS, 1995

Artist contribution to this catalogue.

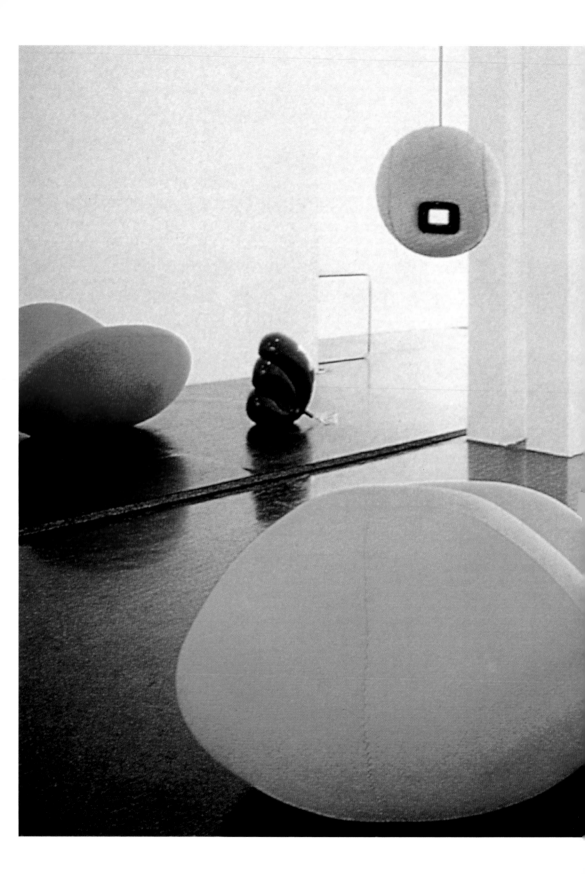

FIGURE 35 Tobias Rehberger

***NO NEED TO FIGHT ABOUT THE CHANNEL. TOGETHER.
LEANT BACK.*** From ***FRAGMENTS OF THEIR PLEASANT
SPACES (IN MY FASHIONABLE VERSION)***, 1996

Seats, tables, television monitors, carpet

Photo courtesy of Friedrich Petzel Gallery, New York
and neugerriemschneider, Berlin

TOBIAS REHBERGER ALSO RESPONDS to the complexities of modern life with work that joins artistic concerns to design, architecture, and individual needs. Often incorporating input from others or drawing on ideas from the history of art, Rehberger explores notions of shared vision and interpretation. Rehberger first entered the public eye in 1995 with a piece executed for a museum in Kassel, Germany, home of the renowned art fair Documenta. Rehberger made sketches of the modernist furniture placed in the galleries of the first Documenta and had the furniture manufactured in miniature based on those sketches. He followed this with a piece in which he roughly sketched designs of classic modernist chairs from memory and then invited craftsmen in Cameroon to construct the chairs based on his sketches. In both projects, Rehberger's third-generation reinterpretation asks viewers to reconsider the traditional and the conceptual in art.

This notion of (re)interpreting our world through the intersection of conceptual art, design, and architecture is best illustrated by *Fragments of Their Pleasant Spaces (In My Fashionable Version)* [1996/1999] FIG. 35/PL. 7. For this installation, Rehberger provides comfortable interiors to satisfy individual desires. Like Zittel's Living Units, Rehberger's installations furnish their users with all the amenities and appear to solve the nagging problems of modern living. To create his fragments, Rehberger considered his ideal interior space and asked friends to describe a "comfortable niche" that would improve their home life. Rehberger's series of high-design "fragments" answered the needs described by his friends. In one—*lying around lazy. not even moving for tv, sweets, coke and Vaseline* (1996)—Rehberger, referred to as a "theraputic interior designer,"[20] installed a daybed surrounded by a television, lamp, and funky containers for snacks. As with Zittel's Living Unit, the owner of this piece has everything at hand to enjoy a lazy day escaping the stresses of the "real" world.

TOBIAS REHBERGER

Rehberger's own personal "fragment," *no need to fight about the channel. together. leant back* (1996/1999) FIG. 35/PL. 7, solved a problem inherent in cohabitating in the technological era, namely how to reconcile two distinct preferences with an endless number of television channels at our disposal. Rehberger and his wife enjoy watching television together and relaxing amid the comforts of home. While Rehberger has a predilection for sports, his wife prefers Hollywood movies. Two womb-like chairs, each with their own identical television monitor suspended above, tastefully solve the problem of what channel to watch. However, while the original version of this piece was at once retro and futuristic, the redesigned version (1999) PL. 7, incorporates a new, more modern aesthetic. In this version, two minimal white chairs sit facing one another and their own more traditional television monitors, allowing Rehberger and his wife to watch each other and their respective programs in harmony.

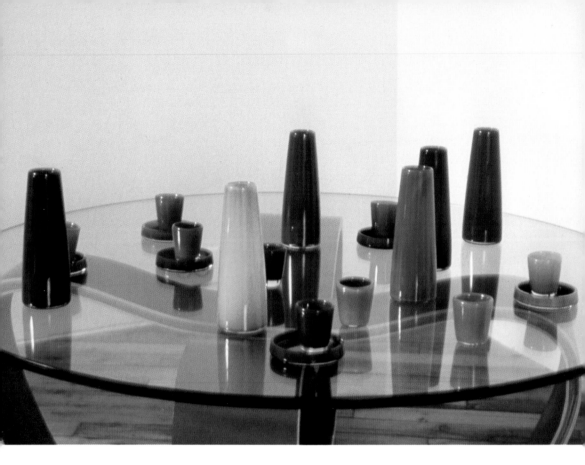

"I LOVE ART, IF IT'S A COMFORTABLE AND WELL-DESIGNED CHAIR." [21]

Jorge Pardo has declared that he is "uncomfortable about being in an exhibition called 'Comfort'." Indeed, Pardo is known for works that challenge the traditional construct of the art object not only by drawing on multiple traditions of fine art, design, and architecture, but by stretching the limits of each practice in relation to the others. Works such as the infamous wooden pier Pardo installed as part of "Skulptur. Projekte, Munster" (1997) and the recent sculpture-cum-house-cum-exhibition-area *4166 Sea View Lane* (1999) *FIGS. 40, 41*, defy categorization and easy interpretation.

Like Rehberger, Pardo is interested in the constantly shifting status of "works of art" that exist at the intersection of art, architecture, and design. However, Pardo's intent is less conceptual and more elusive; his work relies equally on the artist, the viewer, the specific context of the work, and the subtle juxtapositions inherent in its placement to provide meaning. It is precisely in this area of instability and shifting meaning where the work's interest lies. Pardo defines comfort in both the physical and psychological sense of the word. His functional furnishings, redesigned lobby areas, and stylish lighting fixtures are indeed fashionable, pleasing to the eye, and welcoming. The relaxing surfaces of Pardo's work belies a deeper intent that may prove enigmatic for the viewer. Nevertheless, one is encouraged to consider the psychological terrain at the core of his pleasurable environments.

JORGE PARDO

Early in his career, Pardo transformed his gallery into a showroom, displaying comfortable seating areas of his own design and fabrication. While on their surface works such as those grouped under the title *Halley's, Ikeya-Seki, Encke's* (1996) *PL. 2, FIG. 39*, appear to be a mere show of high style and good craftsmanship, they are, like all of Pardo's work, also the site of intersection for a variety of references.

Halley's, Ikeya-Seki, Encke's includes three seating areas. The first consists of four molded plywood chairs surrounding a glass-topped table; the second features a similar glass-topped table with a number of sky and midnight-blue blown-glass vessels sitting on top; and the third, on exhibit in **COMFORT**, includes two molded plywood chairs, one with an ottoman, which accompany a small glass-topped corner table over which hang five unique lighting fixtures with hourglass lampshades made by the artist. Positioned in the corner of the gallery space, the arrangement—named after three comets (Halley's, Ikeya-Seki's, and Encke's)—appears to be, at once, a form of wall-mounted sculpture, a cozy sitting niche, and an earthly counterpoint to the magic of the cosmos. The low-lying seating encourages one to lean back, take a break, and gaze at the constellation of lighting fixtures Pardo has placed above.

FIGURES 40, 41 Jorge Pardo

4166 SEA VIEW LANE

Exhibited as part of a Focus series at The Museum of

Contemporary Art, Los Angeles, October 11–November 15, 1998

Photos courtesy of Friedrich Petzel Gallery, New York

Ultimately, the piece explores the perception of light, the relationship between interior and exterior, and the transformation of the endlessness of the universe into something more manageable and human-scale.

Recently, Pardo put his artistic philosophies into play on a grand scale by designing and building an 1,800-square-foot house in the hills of Los Angeles. The house poses questions regarding the nature of artistic practice, the context of exhibition space(s), privacy, individuality, the marriage of form and function, and the relationship of art and life. Invited by the Museum of Contemporary Art, Los Angeles to create new work, Pardo proposed the building of a house in place of a "traditional" exhibition. The finished "work of art" was subsequently open to the public for tours.

The house sets up an interesting scenario that is key to beginning to understand Pardo's practice. The process of building the house and the myriad questions raised by its status as work of art, exhibition site, and home is ultimately where the work's import lies. It may be argued that once it assumed the status as Pardo's home, the piece became negated. It no longer can be visited and consequently has achieved somewhat legendary status as portrayed through plentiful photographs and articles. Nevertheless, the house stands as the ultimate expression of comfort—for the artist, for whom it is a sanctuary designed with only his needs in mind, and for the art viewer, for whom it offers both the promise of comfort and an alternative way to imagine art functioning in the world.

Like Zittel and Rehberger, Pardo merges art and high style with creature comforts, creating artworks that exceed mere cultural adornment to become functional facets of our environment. If it is true that "art gives us back what technology takes away," then Pardo's artistic practice reintroduces the concept of active engagement—not only in art, but in life—to the viewer, who is typically expected to receive meaning rather than actively create meaning. "My work wants to do something with the material you have in your head once you leave the gallery. It refuses to acknowledge this threshold."[22] While providing comfortable seating areas, lobby areas, and other public and private spaces, Pardo forces the viewer to consider his relationship to art and to his surroundings, challenging us to relax and look at things in a new way.

GREGOR SCHNEIDER ALSO USES HIS WORK AS A VEHICLE to make sense of his surroundings and to search for a construct of comfort, intimacy, and safety. But unlike the other artists in this exhibition, Schneider's work is completely indistinguishable from his life. For the last 15 years Schneider, self-described as "someone working to insulate himself," has been compulsively building and rebuilding his house in Unterheydener Strasse, Rheydt, Germany. Operating from the inside, Schneider has replicated the existing architecture with slight variations to create smaller, more isolated, and presumably protected psychological and physical spaces. Both Pardo's *2166 Seaview Lane* and Schneider's *Haus UR, Rheydt* distinctly collapse each artist's experience of the world into functional dwellings that offer new ways of representing both art and human existence. Yet, while Pardo's house suggests traditional notions of comfort and high-style, Schneider's house pointedly disrupts usual patterns of living.

Schneider's dining room, for example, is slowly rotating around its own axis, with windows that open on to artificial light sources and gentle breezes that are actually simulated by air circulating with the help of a ventilator.

GREGOR SCHNEIDER

Within the house, Schneider builds walls over walls over lead panels over walls over the original wall, completely obscuring the original layout of the house. This layering process effectively soundproofs the rooms and buries any access to the outside world under layers of plaster, lead, and insulation. *Natural* shifts from day to night and changes in the weather are imperceptible; Schneider orchestrates his own shifts in time, season, and weather within the home.

In the gallery setting, Schneider continues his practice by rebuilding actual rooms from his home in Germany, brick by brick. While these rooms reveal no trace of their original context, a walk-through conveys the cramped, minimalist, and cocoon-like feel of the house. Schneider's house is also represented by photographs of the work in progress in Rheydt and video of Schneider moving laboriously through the house. Unlike the exhibited rooms, the photographs and video expose the confined nooks that exist between layers, the back hallways full of building detritus, and the negative spaces created throughout his building project. There is a sense that the latter are the true psychological spaces, recesses where one can escape the actual rooms and find refuge from the world.

Schneider seemingly forgets himself during his working process, escaping into an interior world of his own design and an environment totally under his control. "[Building the house] is a very calming activity," Schneider states. "All jobs involve repeated actions. The bricklayer putting one brick on another. We positively long for it. It has to do with meditation, with becoming calm, with being involved in an activity. . ."[23] With this project, Schneider proposes that the city, in fact the world itself, is as intimate as one can make it.

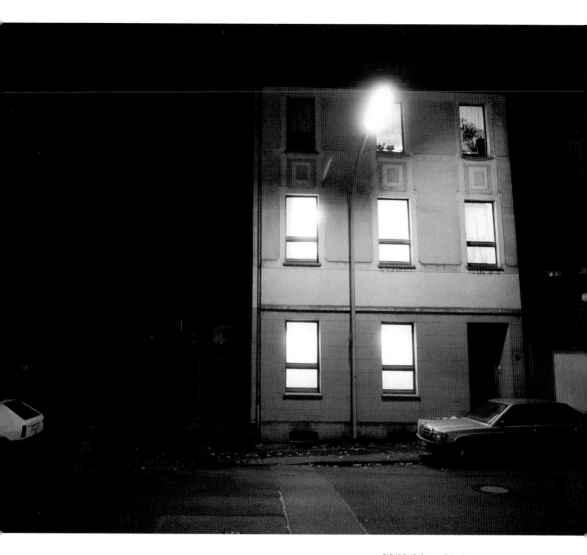

FIGURE 42 Gregor Schneider

TOTES HAUS UR, RHEYDT, 1985-2000

Black-and-white photograph

Photo courtesy of Galerie Luis Campaña, Cologne

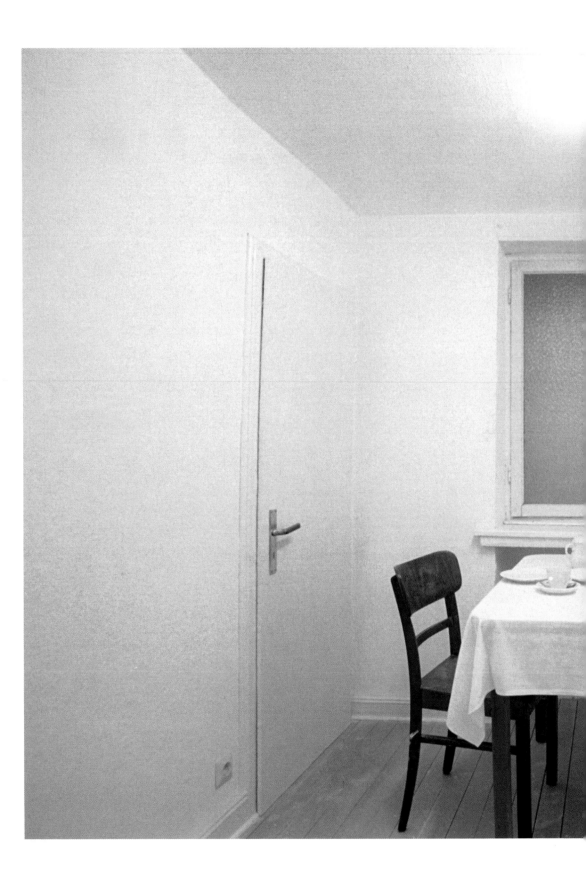

FIGURE 43 Gregor Schneider
DREHENDES KAFFEE-ZIMMER, WIR SITZEN, TRINKEN
KAFFEE UND SCHAUEN EINFACH AUS DEM FENSTER,
UR 10, REYDT, 1993
Mixed media installation
Photo courtesy of Galerie Luis Campaña, Cologne

"WHETHER ARCHITECTS OR ARTISTS SEEK TO SOLVE the problems inherent in metro-
politan life with material or utopian solutions, or simply to represent them in all their implicit horror
and excitement, the need to develop new forms of expression was and is the result."[24]

As the virtual revolution presses on, man is necessarily motivated to make sense of his
new status in the world. With technology, in many respects, taking the place of human
interaction and primary experience, negotiating avenues to understand and experience
the physical world becomes an essential means toward peace of mind. At the heart of all
of the work in this exhibition is the corporeal; an abiding concern for how we as humans
move through a city or live in a house—how we activate the spaces we inhabit. It is in this
active engagement, a disavowal of the passive experiences promoted by new media,
where one solution lies. **THE EIGHT ARTISTS IN COMFORT DEMONSTRATE
THAT AS REALITY IS BECOMING LESS AND LESS TANGIBLE,
IT IS ALSO BECOMING MORE AN IMAGINARY SPACE THAT CAN BE CREATED
AND ANIMATED ACCORDING TO INDIVIDUAL DESIRE AND NECESSITY.**

FIGURE 44 Gregor Schneider

Film stills from **NACHT-VIDEO,** 1996

Black-and-white video projection with sound

Photo courtesy of Galerie Luis Campaña, Cologne

1. By nature of my background, as well as that of the participating artists, the focus of this exhibition and accompanying essay is decidedly Western, addressing the situation within industrialized nations.

2. Jonathan Crary, "Electronic Attractions, Resistant Reveries," in *CI:99/00/V01 Carnegie International 1999/2000,* exhibition catalogue published by the Carnegie Museum of Art, Pittsburgh, PA, 1999, p. 129.

3. From remarks by Dave Hickey presented at the conference "Curating Now: Imaginative Practice/Public Responsibility," Philadelphia, PA, 2000.

4. Peter Land. Excerpted from a proposal for *Step Ladder Blues,* 1998.

5. Peter Land. Excerpted from a proposal for *The Staircase,* 1998.

6. Guy Debord, *The Society of the Spectacle,* (New York City: Zone Books), 1994, p. 12.

7. Guy Debord, "Theory of the Dérive," from *The Situationist International Anthology,* edited and translated by Ken Knabb (Berkeley: Bureau of Public Secrets), 1989, p.50.

8. Gabriel Orozco, "A Thousand Words: Gabriel Orozco Talks About His Recent Films," *ArtForum,* Summer 1998, p. 115.

9. From an interview with Sarah Morris by Michael Tarantino and Rob Bowman in *Modern Worlds,* exhibition catalogue published by the Museum of Modern Art, Oxford, England, 1999, p. 50.

10. Ibid., p. 48.

11. Ibid., p. 48.

12. Raimar Stange, "On the Road Again," from *Off,* exhibition catalogue published by Kasseler Kunstverein, Köln, 1999, p. 94.

13. Madeleine Grynsztejn, "CI:99/00," in *CI:99/00/V01 Carnegie International 1999/2000,* exhibition catalogue published by the Carnegie Museum of Art, Pittsburgh, PA, 1999, p.125.

14. Marcella Beccaria, "B.I.T." from a brochure accompanying an Ackermann exhibition at the Castello di Rivoli, 2000.

15. Ibid.

16. In these works, Zittel was concerned with the organization of a life "for the breeding and management of various animals." With "A-Z Administrative Services," Zittel has adapted these organizational schemes into her own life. For further information on Zittel's breeding units see *Weird Science,* exhibition catalogue published by the Cranbrook Art Museum, Bloomfield Hills, MI, 1999.

17. From an interview with Andrea Zittel in *Andrea Zittel: Living Units,* exhibition catalogue published by the Museum for Gegenwartskunst, Basel, Switzerland, 1996, p. 15.

18. From e-mail correspondence with the artist, August 18, 2000.

19. Andrea Zittel, "A-Z Deserted Islands: A Proposal for Sculpture Show in Muenster," 1997.

20. Maria Lind, *Tobias Rehberger,* exhibition catalogue published by the Kunsthalle, Basel, Switzerland, 1998.

21. Camiel Van Winkel, "Off the Table," in *Parkett,* No. 56, 1999, p. 142.

22. Jan Tumlir, "Jorge Pardo: From Station to Station," in *jorgepardountitled,* exhibition catalogue published by the Royal Festival Hall, London, 1999.

23. From an interview with Gregor Schneider by Ulrich Loock in *Gregor Schneider: Totes Haus ur/Dead House ur/Martwy Dom ur,* catalogue published by the Städtischen Museums Abteilberg Mönchengladbach, Frankfurt, Germany, p.52.

24. Anthony Vidler, in the Preface to *Warped Space: Art, Architecture, and Anxiety in Modern Culture,* (Cambridge: The MIT Press), 2000, p. ix.

FIGURE 45 Franz Ackermann
Color photograph
Artist contribution to this catalogue.

Height precedes width precedes depth.

EXHIBITION CHECKLIST

1. Franz Ackermann
 Abschied auf See, 2000
 Oil on canvas
 107 x 215 inches
 Courtesy of the artist and neugerriemschneider,
 Berlin

2. Franz Ackermann
 untitled (janis joplin), 2000
 Mixed media installation
 107 inches high, 207 inches diameter
 Courtesy of the artist and neugerriemschneider,
 Berlin

3. Peter Land
 Everybody Is a Star, 1998
 Wall drawing, glass, bottle of whiskey,
 audio headsets
 Dimensions variable
 Courtesy of the artist and Galleri Nicolai Wallner,
 Copenhagen

4. Peter Land
 *Hi—I'm new around here so please don't rob me,
 mug me or kill me. Could you instead please direct
 me to a cheap hotel (New York City),* 1996
 Color photographs
 Courtesy of the artist and Galleri Nicolai Wallner,
 Copenhagen

5. Peter Land
 The Staircase, 1998
 Double video projection
 Courtesy of the artist and Galleri Nicolai Wallner,
 Copenhagen

6. Peter Land
 Survival Kit, 1998/99
 Installation including wooden box, star telescope,
 bottle of whiskey, drinking glass
 Dimensions variable
 Courtesy of the artist and Galleri Nicolai Wallner,
 Copenhagen

7. Sarah Morris
Capital, 2000
16mm/DVD, 18 minutes 18 seconds
Courtesy of the artist, Friedrich Petzel Gallery,
New York and Jay Jopling/White Cube, London

8. Sarah Morris
Midtown, 1998
16mm/DVD, 9 minutes 36 seconds, edition of 3
Courtesy of the artist, Friedrich Petzel Gallery,
New York and Jay Jopling/White Cube, London

9. Sarah Morris
Midtown—Armitron, 1999
Household gloss on canvas
84.2 x 84.2 inches
Collection of MORA Foundation

10. Sarah Morris
Neon—Flamingo Hilton (Las Vegas), 1999
Household gloss on canvas
84.2 x 84.2 inches
Collection of Mr. and Mrs. David Hayden

11. Sarah Morris
Neon—Rumjungle (Orange) [Las Vegas], 1999
Household gloss on canvas
84.2 x 84.2 inches
Collection of Dr. Raffy and Vicki Hovanessian,
Chicago IL

12. Gabriel Orozco
From Dog Shit to Irma Vep, 1997
From Green Glass to Federal Express, 1997
From Flat Tire to Airplane, 1997
From Cap in Car to Atlas, 1997
From Container to Don't Walk, 1997
Color videos
Courtesy of the artist and Marian Goodman Gallery,
New York

13. Gabriel Orozco
Island Within an Island, 1993
Cibachrome photograph
16 x 20 inches
Courtesy of the artist and Marian Goodman Gallery,
New York

14. Jorge Pardo
Halley's, Ikeya—Seki, Encke's, 1996
9 elements: wood, lacquer, glass, metal, electrical
components
Dimensions variable
Private Collection, New York

15. Jorge Pardo
Untitled, 1994
Acrylic on wood
790 x 120 inches
Collection of the Museum of Contemporary Art,
North Miami FL

16. Jorge Pardo
Untitled, 2000
Artist's book
Courtesy of the artist

17. Tobias Rehberger
*smoking, listening for himself—I care about you
because you do. From Fragments of their Pleasant
Spaces (In My Fashionable Version),* 1996
Mixed media
Dimensions variable
Private collection. Courtesy of neuggerriemschneider,
Berlin

18. Tobias Rehberger
*smoking, listening for himself—I care about you
because you do. From Fragments of their Pleasant
Spaces (In My Fashionable Version),* 1999
Mixed media
Dimensions variable
Private collection. Courtesy of neuggerriemschneider,
Berlin

19. Gregor Schneider
Nacht-Video, 1996
Black-and-white video projection with sound
26 minutes
Courtesy of the artist; Galerie Luis Campaña,
Cologne; and Konrad Fischer Galerie, Düsseldorf

20. Gregor Schneider
Photographs from Totes Haus Ur, Rheydt, 1985-2000
Black-and-white photographs
12 x 10 / 16 x 12 inches each
Courtesy of the artist; Galerie Luis Campaña,
Cologne; and Konrad Fischer Galerie, Düsseldorf

21. Gregor Schneider
Totally Isolated Guestroom, Ur 12, 1995
Mixed media installation
Dimensions variable
Collection of Dr. Thomas Waldschmidt, Cologne,
Germany

22. Andrea Zittel
A-Z Carpet Furniture, 1995
Silk and wool dye on wool carpet
8 x 8 feet
Courtesy of Andrea Rosen Gallery, New York

23. Andrea Zittel
A-Z Comfort Unit, 1994
Steel, wood, metal, mattress, glass, mirror, lighting
fixture, stove, oven, green velvet
57 x 84 x 82 inches
Collection of the Cincinnati Art Museum. Gift of
RSM Co., by exchange.

FRANZ ACKERMANN WAS BORN IN NEUMARKT ST. VEIT, WEST GERMANY. He currently lives and works in Berlin. Since 1997, Ackermann's paintings, drawings and installations have been included in solo and group exhibitions through-out Europe and the United States, most recently in Glee, Aldrich Museum for Contemporary Art; the Carnegie International, Pittsburgh; Dream City, Kunst-verein München, Munich; and go away: artists and travel, Royal College of Art, London. Ackermann studied at the Akademie der Bildenden Künste, Munich and Hochschule für bildende Künste, Hamburg. He is represented by neugerriemschneider, Berlin.

PETER LAND WAS BORN IN 1966 IN AARHUS, DENMARK. He currently lives and works in Copenhagen. Land studied at Goldsmith College, London and The Royal Danish Academy of Fine Art, Copenhagen. Recent exhibitions include a number of group shows around Europe and the U.S. and solo shows at Tanja Grunert & Klemens Gasser, New York; Centre d'Art Contemporain, Fribourg, Switzerland; and the video gallery of the Museum of Contemporary Art, Chicago. Land's work can be found in such collections as the Museum of Contemporary Art, Helsinki, Finland; the Musée National d'Art Moderne, Centre George Pompidou, Paris, France; and The National Museum of Contemporary Art, Oslo, Norway. He is represented by Galeri Nicolai Wallner, Copenhagen.

ARTIST BIOGRAPHIES

SARAH MORRIS WAS BORN IN 1967 IN THE UNITED STATES. She currently lives and works in New York and London. Recent solo exhibitions have been mounted at the Kunsthalle, Zurich; Jay Jopling/White Cube, London; Philadelphia Museum of Art and the Museum of Modern Art, Oxford. Morris' work has also been featured in numerous group exhibitions including SlideSurface/Things, Museum Ludwig; What If, Moderna Museet, Stockholm; and Frieze, Institute of Contemporary Art, Boston. Her work can be found in Saatchi Collection, London; PaineWebber Collection, New York; Fondazione Prada, Milan; and the Centre d'Art Contemporain, Dijon. She is represented by Friedrich Petzel, New York and Jay Jopling/White Cube, London.

GABRIEL OROZCO, BORN IN 1962 IN JALAPA, VERACRUZ, MEXICO, is arguably one of this decade's most exciting artists. His work is the subject of a major traveling retrospective organized by the Museum of Contemporary Art, Los Angeles and has been featured in recent international exhibitions including the Carnegie International, Pittsburgh; the 1997 Whitney Biennial; and Documenta X, Kassel. Orozco has presented solo exhibitions since 1993, including shows at the Museum of Modern Art, New York; Museum of Contemporary Art, Chicago; the Art Gallery of Ontario, Toronto; and the Institute of Contemporary Art, London. Orozco currently lives and works in New York and Mexico City. He is represented by Marian Goodman Gallery, New York.

JORGE PARDO WAS BORN IN 1963 IN HAVANA, CUBA and currently lives and works in Los Angeles. Pardo studied at the University of Illinois, Chicago and the Art Center College of Design, Pasadena, California. Recent exhibitions/ public projects have been mounted at the Dia Foundation in New York; the Fabric Workshop and Museum, Philadelphia; Kunsthalle, Basel; Galerie Gisela Capitain, Cologne; Sculpture Projects in Munster; Gallerie Marta Cevera, Madrid; and most notably, his house as sculpture, 4166 Sea View Lane for the Museum of Contemporary Art, Los Angeles. He is represented by Friedrich Petzel Gallery, New York and neugerriemschneider, Berlin.

TOBIAS REHBERGER WAS BORN IN 1966 IN ESSLINGEN, GERMANY and received his MFA at Hochschule fuer Bildende Kunst, Frankfurt, Germany. His most recent large-scale installation is located on the plaza of the Museum of Contemporary Art, Chicago. Other exhibitions include Against Design, Institute of Contemporary Art, Philadelphia; Sunny Side Up, University of California, Berkeley; and The Improvement of the Idyllic, Galeria Heinrich Ehrhardt, Madrid. He currently lives and works in Frankfurt, Germany and is represented by Friedrich Petzel Gallery, New York and neugerriemschneider, Berlin.

GREGOR SCHNEIDER WAS BORN IN RHEYDT, WEST GERMANY and has been exhibiting his work since 1992. He has had solo gallery exhibitions in Düsseldorf, Berlin, Cologne, Tokyo, Amsterdam, London, Warsaw and Milan and has been included in numerous group exhibitions including Wonderland, St. Louis Museum of Art; Carnegie International, Pittsburgh; No Man's Land, Museum Haus Lange; Performing Buildings, Tate Gallery, London; and Anarchitecture, De Appel Foundation, Amsterdam. He currently lives and works in Rheydt, Germany and is represented by Galerie Luis Campaña, Cologne and Konrad Fischer Galerie, Düsseldorf.

77

ANDREA ZITTEL HAS EXHIBITED HER DESIGN MASTERPIECES from the A-Z product line extensively in the United States and Europe since 1988. She was born in California, received her MFA from the Rhode Island School of Design, and currently lives and works in Altadena, California. She has had solo exhibitions at such prestigious venues as Museum for Gegenwartskunst, Basel; San Francisco Museum of Modern Art; The Carnegie Museum of Art; and numerous galleries. Recent group exhibitions include Weird Science, Cranbrook Museum of Art; the Berlin Biennial (1998); Wexner Center for the Arts, Columbus; and the Museum of Modern Art, New York. She is represented by Andrea Rosen Gallery, New York.

FIGURE 46 Gregor Schneider
Black-and-white photograph
Artist contribution to this catalogue.